BLANK COMIC BOOK
DRAW YOUR OWN!

 Get Creative 6

New York

D1410637

HOW TO USE THIS BOOK

As you flip through this draw-your-own comic book, you'll notice that it is divided into six separate sections, giving you the option of creating up to six different short comic books. Each section begins with the cover template shown right, where you can draw the cover and add lettering for the title. Use these pages to create the next cover in your original series or to start an entirely new comic adventure.

The rest of the templates in this book provide a framework for creating your very own comic story, complete with single-frame splash pages for drawing dramatic images that deserve special focus. You may find it helpful to fit your story within this framework, but feel free to experiment! Stretch your drawings across several separate frames if you like. There is no wrong way to go about it.

Speech balloons are also included on each template page to allow for the placement of text and dialogue. Use them as they appear or find creative ways to incorporate them into your artwork. The choice is yours.

For more instruction on how to effectively use splash pages, comic templates, speech balloons, and comic-book lighting, keep reading.

Cover template

Page template

PANEL SEQUENCE

The visual flow of a story is the most important aspect of laying out a page of sequencial panels. To do this, we begin to vary the type of "shots" in a panel. Too often, beginners do too much in full shots, so their comic book pages are filled with characters drawn head to foot, with no close-ups or medium shots. Also, you should begin to include other angles instead of relying exclusively on front angles. Let's see how using a variety of angles creates a sense of energy and dynamism in a scene.

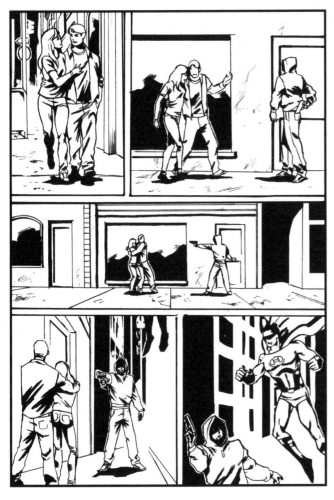

BEGINNER APPROACH

Some shots are varied. The characters are good. What's wrong? The main even (the hold up) is repeated in two panels, and there are no closeups or medium shots to jar the reader. This is a sleepy page.

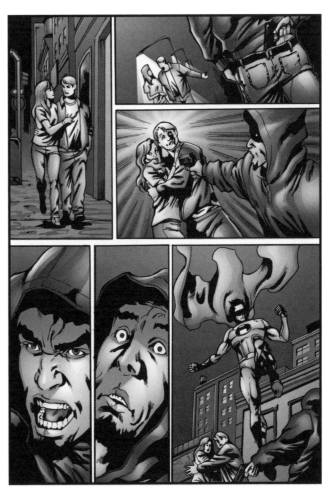

PRO APPROACH

The first shot is neutral to set up the story and give the reader information fast and simple. Danger starts to happen in the second and third panels, which is why the angle has been tilted. Then we go in tght for a couple of quick close-ups of the dangerous guy in panels 4 and 5. In panel 6, the shot widens out for the climactic moment when the superheo enters the picture.

THE SPLASH PAGE

THE SPLASH PAGE is a scene that takes up an entire page, not just a panel. Your job is to direct the eye to the important elements of the scene. To do this, you need to create a *circle of focus*. This means placing the main elements of the action on a continuous loop, so you keep the eye from traveling out of the scene.

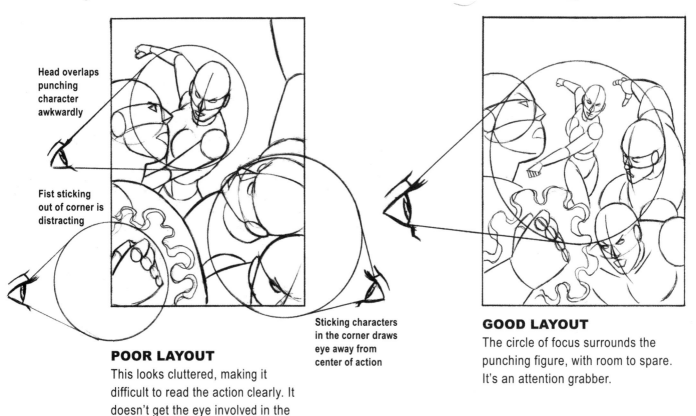

Head overlaps punching character awkwardly

Fist sticking out of corner is distracting

Sticking characters in the corner draws eye away from center of action

POOR LAYOUT

This looks cluttered, making it difficult to read the action clearly. It doesn't get the eye involved in the scene.

GOOD LAYOUT

The circle of focus surrounds the punching figure, with room to spare. It's an attention grabber.

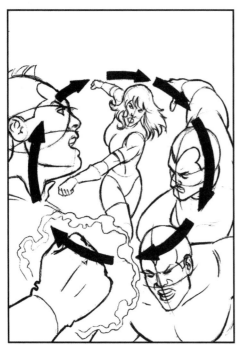

CONTINUOUS FLOW ESTABLISHED

In the cleaned-up version, the circle of focus becomes even clearer: A circular path through the layout creates one continuous loop, keeping the eye from wandering off the page.

FINAL LAYOUT

Putting it all together, we can feel the punch. We also experience the impact on those bad guys. The action is clear and uncluttered. And we get a sense of depth from positioning figures in the foreground and others in the background.

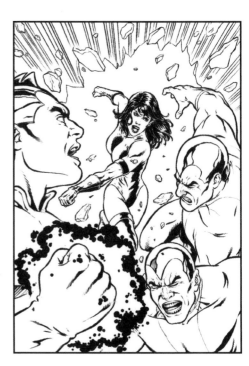

SPEECH BALLOONS AND CAPTIONS

SPEECH BALLOONS are first read left to right and then top to bottom. The primary direction is always left to right. Poorly placed speech balloons mean the reader has to reread the balloons in a different order to make sense of them. The last thing you want to do is frustrate your readers with speech balloons that are laid out confusingly.

CAPTIONS are the rectangular boxes set with quick snippets of information to cue the reader into the scene, like box 1 in the examples below.

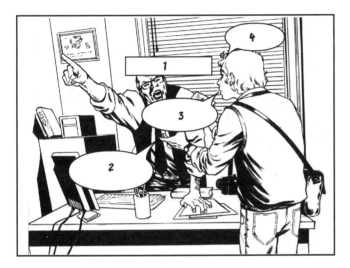

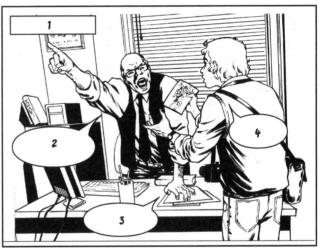

INCORRECT PLACEMENT

After all your hard work of drawing a perfectly good scene, don't obliterate it with caption boxes and speech balloons covering the characters.

CORRECT PLACEMENT

Counterclockwise placement of caption boxes and speech balloons is effective, provided that these elements still read from left to right and that they leave the image uncluttered.

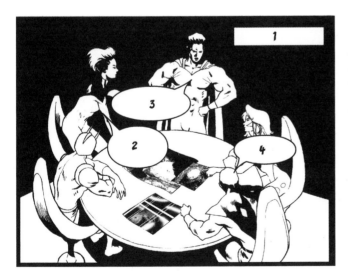

INCORRECT PLACEMENT

Here, the speech balloons invade the center of the scene and steal the focus away from the characters. In addition, their order is all mixed up.

CORRECT PLACEMENT

The two characters at the top of the page are engaged in a dialogue and therefore must speak sequentially; that's why balloon 3 must follow balloon 2.

COMIC BOOK LIGHTING

COMIC BOOK LIGHTING is more dramatic than what we see in real life. To achieve this stylized look, we use shadows to create intensity and dramatic contrast. Shadows vary in placement depending on the position of the light source. Let's see how to add this effective accent to your drawings.

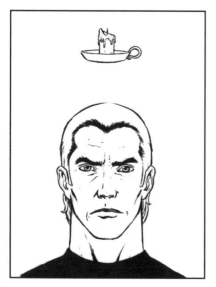

NO LIGHT SOURCE
The candle is not yet illuminated, so the figure exhibits no shadows and has limited impact.

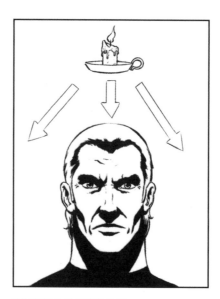

LIGHT SOURCE DIRECTLY OVERHEAD
Overhead light casts shadows downward onto the face and neck. This creates a hard look.

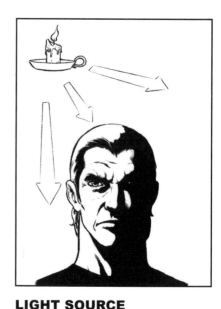

LIGHT SOURCE FROM THE LEFT
Light hits the character diagonally, throwing shadows over almost all of the right part of the face and neck. It's an excellent, moody look.

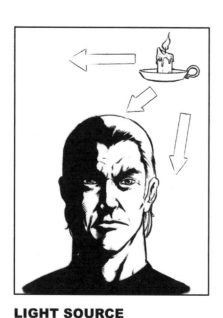

LIGHT SOURCE FROM THE RIGHT
Place the light source to the right, and shadows form to the left.

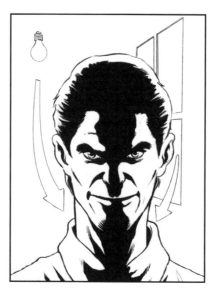

OPPOSING LIGHT SOURCES
Having light sources on both sides of the head or figure is a cool look, pooling up black shadows vertically down the middle of the face. It's often seen at intense moments.

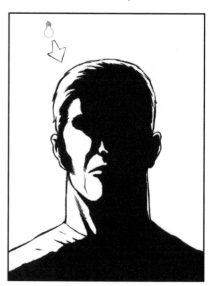

FAINT LIGHTING
Low-voltage light appears in environments such as dark warehouses, prison cells, and creepy castles. The effect it yields is called *edge lighting*, because the rim of the darkened figure is illuminated.

1001001

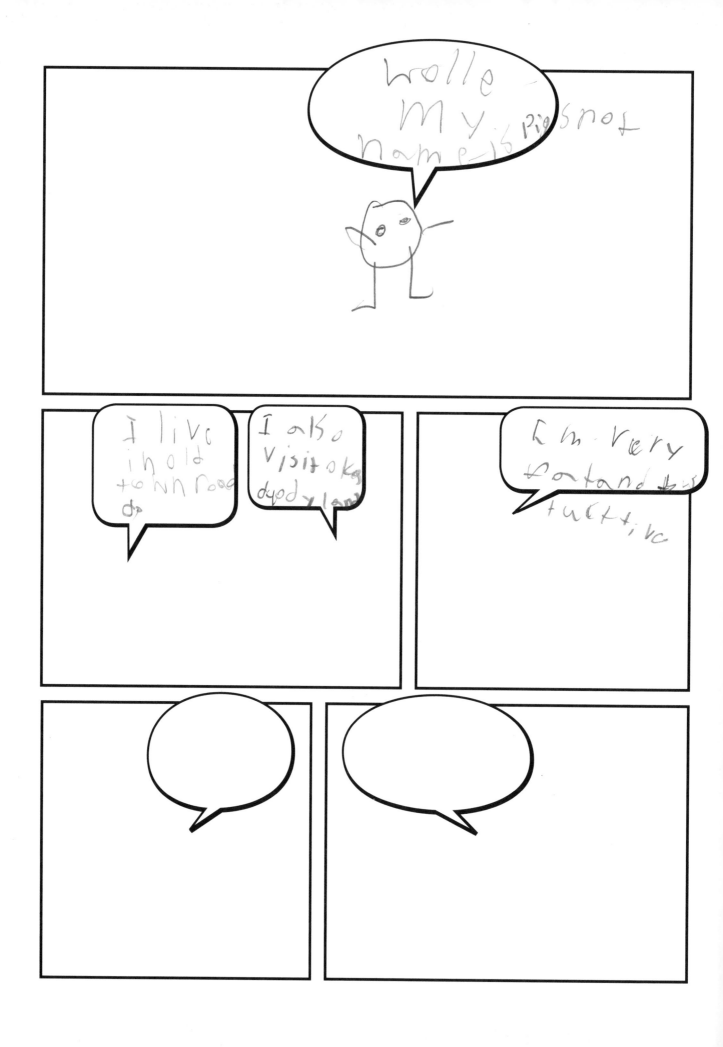

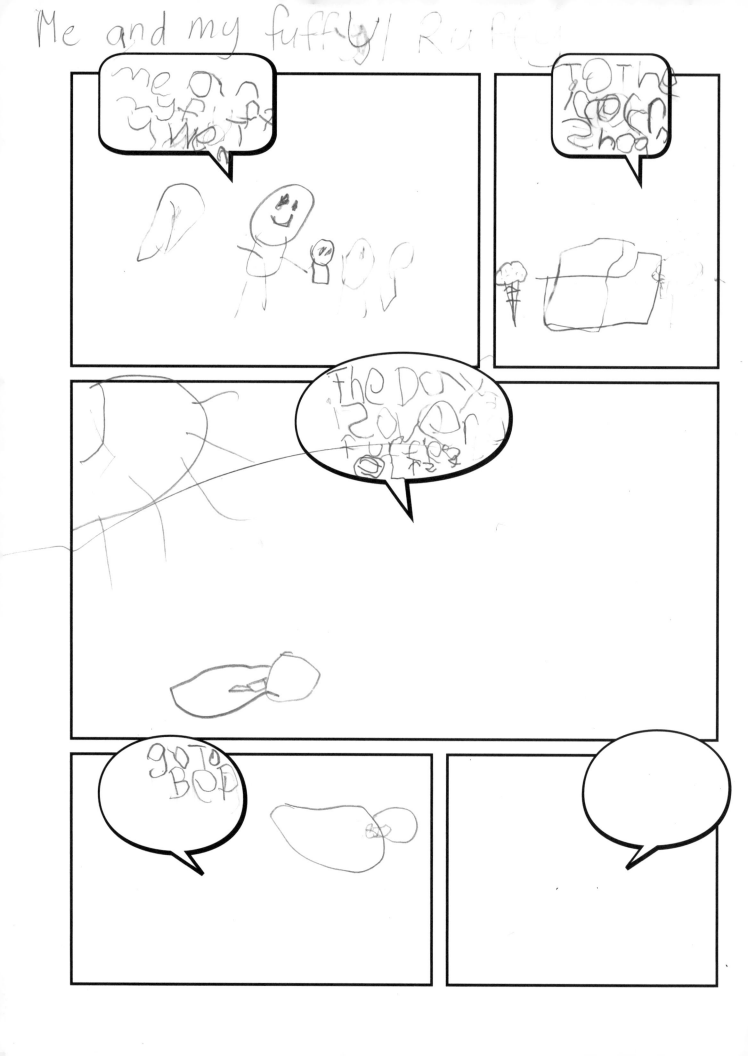

Printed in China

357910864